Contents

Supported by the National Lottery through the
Heritage Lottery Fund

Maritime GREENWICH
A WORLD HERITAGE SITE

Welcome!

Welcome to the largest maritime museum in the world! Our purpose is to illustrate the importance of the sea, ships, time and the stars, and their relationship with people, using our collection of over two million items – treasures of art, artefact and record which help trace Britain's long and world-wide relationship with the sea.

Set in a Royal Park and with some of Britain's finest museum buildings – including the historic Queen's House and the Royal Observatory, the 'home of time' – the Museum forms part of the Maritime Greenwich World Heritage Site and is easily reached from central London.

Our activities include research, scholarship, educational programmes and publishing at many levels. Our forty-five galleries, including those in the Observatory and Queen's House, tell many stories: of sea-borne exploration and adventure, of heroic success (and sometimes failure), of science, technology, trade and the arts. We aim for fresh and stimulating interpretations, with a wealth of material for the young of all ages, drawing together the complex strands of global maritime affairs.

Enjoy our galleries, take part in our learning activities, visit our award-winning website (www.nmm.ac.uk) and, if there is anything further that we can do to assist you, please ask any member of staff. We are all here to help your discovery of what we can offer.

Roy Clare
Director, National Maritime Museum

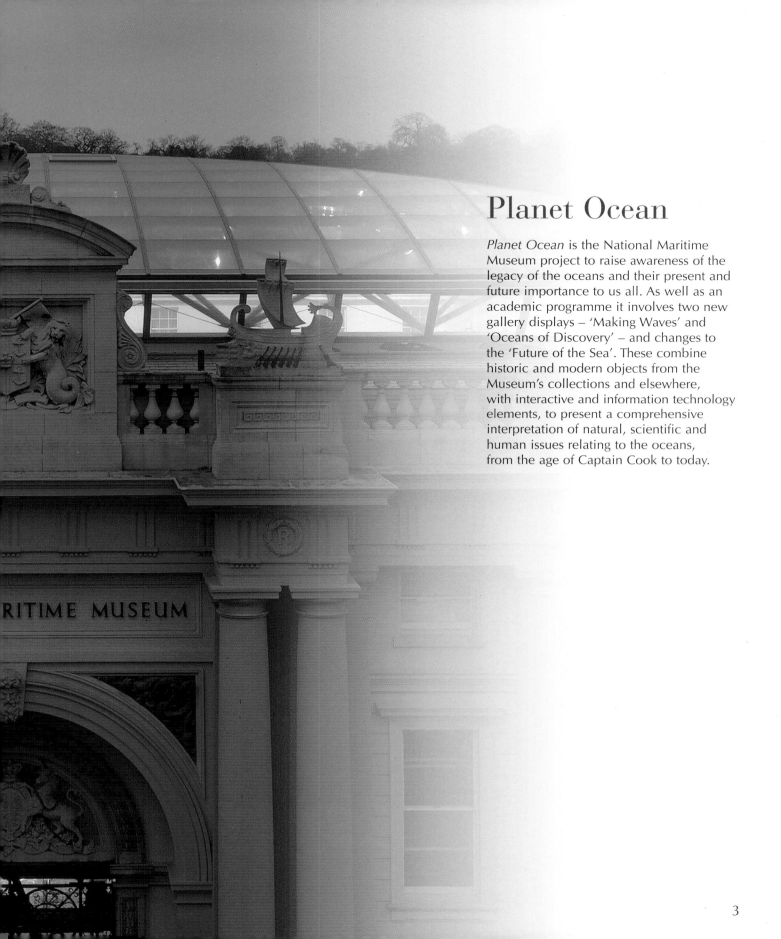

Planet Ocean

Planet Ocean is the National Maritime Museum project to raise awareness of the legacy of the oceans and their present and future importance to us all. As well as an academic programme it involves two new gallery displays – 'Making Waves' and 'Oceans of Discovery' – and changes to the 'Future of the Sea'. These combine historic and modern objects from the Museum's collections and elsewhere, with interactive and information technology elements, to present a comprehensive interpretation of natural, scientific and human issues relating to the oceans, from the age of Captain Cook to today.

Nelson

'I will be a hero! And confiding in Providence, I will brave every danger.'
NELSON

Horatio Nelson (1758-1805) was the most popular British hero of the late 18th and 19th centuries. His naval exploits were commemorated in many ways in his own time and his final, famous message to the fleet at Trafalgar, urging every man there to do his duty, has echoed down the years.

Nelson succeeded in appealing to all sections of society. Born in Norfolk in 1758, the son of a country parson, he began his naval career at the age of twelve. He ended it having lost an arm and the sight in one eye, as an admiral and a peer of the realm, on board the *Victory* at Trafalgar in 1805. His great naval victories were gained by a combination of tactical genius and his ability to inspire all who served with him, whether his fellow officers or ordinary seamen. His death was an occasion of national mourning, an outpouring of grief in the midst of the French Wars. His dramatic funeral in St Paul's Cathedral was attended by royalty, politicians and survivors of the Battle of Trafalgar.

Nelson's reputation as a role model has not always been high. Since the First World War, for example, the cult of personal sacrifice which he represents, has been open to much critical questioning. Nelson's personal reputation has also varied. The Victorians disapproved of his private life, which has also been much examined in print and on film, not always to his advantage: in particular, his desertion of his wife and his passionate relationship with Emma, Lady Hamilton.

Ironically, in that process the image of Nelson has again come to chime with modern sensibilities. He is now seen as a man with familiar fears and flaws, yet still with the courage to lead by example.

Today, almost two centuries after his death, the 'immortal memory' of Nelson endures. Few other historical figures have so resoundingly survived such changes of fortune.

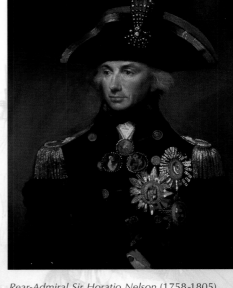

Rear-Admiral Sir Horatio Nelson (1758-1805), painted 1798-99 by Lemuel Francis Abbott (1760-1803). [BHC2889]

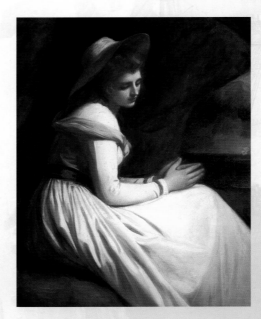

Emma Hamilton (c.1765-1815), 1785, by George Romney (1734-1802). Romney painted several portraits of Emma when she was a teenager. She did not meet Nelson until 1793 in Naples, where her husband, Sir William Hamilton, was then the British Ambassador. [BHC2736]

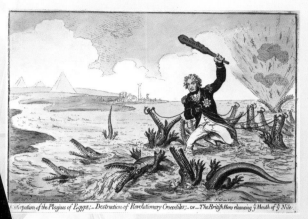

Etching by James Gillray (1757–1845), depicting Nelson beating the French 'Revolutionary Crocodiles' at the Battle of the Nile, 1798. The erupting crocodile represents *L'Orient*, the exploding French flagship. [A33255]

Nelson's undress uniform coat. Emma Hamilton received this coat – with the fatal bullet hole clearly visible in the shoulder. [B9701-2]

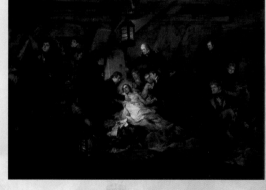

The Death of Nelson, painted in 1805-07, by Arthur William Devis (1763-1822). Nelson was carried down to the orlop deck, and lived for a further three hours. At 3.15pm Captain Hardy brought the news that the battle was won. Nelson died shortly afterwards. [BHC2894]

The Battle of Trafalgar, 21 October 1805, by Joseph Mallord William Turner (1775-1851). This picture is a conflation of several incidents in the battle. [BHC0565]

1/58

1771

1787

Marries Frances Nisbet

1797

1798

1799

1801

1803

1805

Joins *Raisonnable* as a midshipman

29 September at Burnham Thorpe, Norfolk

After the Battle of St Vincent, Nelson is created
Knight of the Bath and promoted to Rear-Admiral

Crushing defeat of the French fleet at Aboukir Bay, Egypt.
Nelson is created Baron Nelson of the Nile

After his part in saving the royal family of Naples,
Nelson is created Duke of Bronte by the King of Naples.
He begins his relationship with Lady Hamilton

Destruction of the Danish fleet at
the Battle of Copenhagen

Nelson is made Commander-in-Chief
in the Mediterranean

On 21 October the Mediterranean
fleet under Nelson engages with
the Franco-Spanish fleet off Cape
Trafalgar. Mortally wounded,
Nelson dies on board his flagship
Victory, shortly after hearing the
news of the enemy's defeat

The great age of passenger travel at sea came during the 19th and early 20th centuries, with the massive expansion of emigration and, later, tourism.

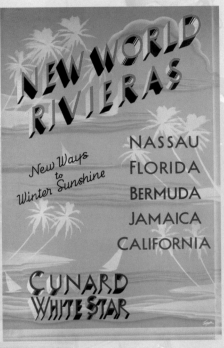

Poster advertising White Star cruises, published about 1935. Cunard turned to short breaks to profit from Americans eager to escape the prohibition of alcohol at home. [D9663]

European migrants fled wars, poverty, and religious and political persecution in search of a better life, mainly to the USA. Shipping lines provided transport and cheap fares, although conditions were crowded and unhealthy. Leisure travellers were initially carried as a sideline to more lucrative contracts, such as the transport of emigrants or mail between Europe, America and British imperial possessions in India and Africa. But good passenger facilities brought status and increasing custom. Emigration sometimes subsidised tourism using liners large enough to carry both classes of passenger, although in very different standards of accommodation.

Between the 1840s and the 1930s, goods and mail transportation, tourism and migration fuelled the rise of famous shipping lines such as Cunard, the Peninsular & Oriental Steam Navigation Company (P&O), the White Star Line, Nord-deutscher Lloyd, and the French Compagnie Général Transatlantique (CGT). The fiercely competitive transatlantic trade grew rapidly. Ships competed for the Blue Riband award for the fastest crossing. For all classes, the attraction of sea travel lay in its promise. The rich looked forward to the experience of a lifetime with abundant

> **FACT FILE**
> In 1845 the *Great Britain* took 15 days to cross the Atlantic. In 1897 the German *Kaiser Wilhelm der Grosse* captured the record but by 1907 the *Mauretania* had won back the Blue Riband for Britain, crossing in under five days.

food, service and entertainment. The dream of the emigrant was one of arrival in a country where – so it was said – land was free and fertile, religious and political dissent was tolerated, and class divisions did not exist.

New entry restrictions slowed emigration to the USA after 1918. After the Second World War other destinations such as Canada and Australia became more popular, encouraged by governments. People from the Commonwealth, already a presence in Britain's cities, began their own mass migrations.

Shipping lines began to introduce one-class travel for cruises and holiday customers but air transport gradually seized the largest share of the market. Mass 'liner' travel by sea has now ended except for a much smaller number of ships which continue in the luxury cruise trade.

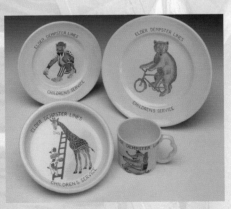

Selection of children's china used on Elder Dempster Line ships in the mid-20th century. This company served colonies in British West Africa. [D9691]

1837

Peninsular Steam Navigation Co. founded in London to transport goods and mail between Britain and Spain. Becomes P&O in the 1850s after securing routes to Egypt and Australia

1838

Samuel Cunard and partners establish the British and North American Royal Mail Steam Packet Co. with four ships

1850

William Inman's Liverpool and Philadelphia Steam Ship Co. (the Inman Line) founded to carry transatlantic emigrants

1869

Opening of the Suez Canal. T.H. Ismay and part form the Oceanic Steam Navigation Co. (the W Star Line) in Liverpool

A doll won in a raffle on the liner *Stratheden* at Christmas in 1938 while *en route* to India. [D9595]

Model of the *Mauretania*, 1907. When she came in to service this fast and luxurious liner was marketed as the 'eighth wonder of the world.' In 1907, a return trip to America in one of her regal suites cost the equivalent of £20,000 in today's money. [D5798]

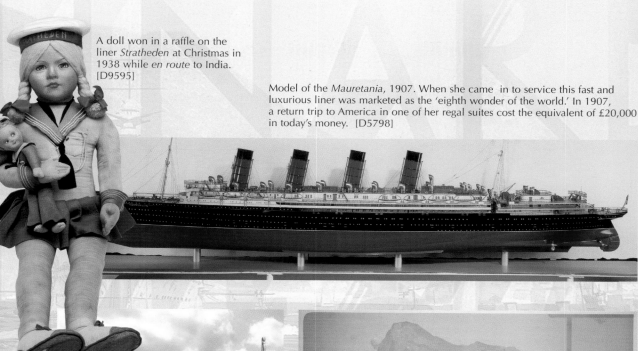

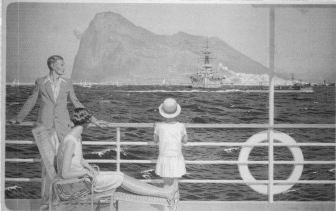

The *Oriana* was built as a replacement for the most successful ship in P&O history, the *Canberra*. She was designed to look as similar as possible, with the funnels, gentle streamlining and other features of the *Canberra*, and was seen as a worthy successor. P&O wanted the 67,000 ton vessel to be built in a British shipyard but the contract eventually went to a German firm. [D8017-10]

'Gibraltar', Empire Marketing Board poster published in 1928. One of a series depicting a typical English family *en route* to the East. The illustrator was Charles Pears. [D9696]

1903
British government intervenes to prevent Morgan purchasing Cunard and between 1907 and 1914 subsidises Cunard's building of the ships *Mauretania*, *Lusitania* and *Aquitania*

Morgan's International Mercantile [Marin]e Co. acquires the White Star Line

1911-12
Maiden voyage of the White Star Liners *Olympic* (1911) and her sister ship the *Titanic* (1912), sunk *en route* to New York with massive loss of life

1926
The French Compagnie Général Transatlantique launches the *Ile de France*. The White Star Line returns to British ownership

1934
Cunard absorbs the ailing White Star Line

1935
Maiden voyage of the 80,000-ton *Normandie* with 1,972 passengers

1936
Maiden voyage of Cunard's *Queen Mary*. The ship is 1,019 ft long, carries 2,139 passengers, and 1,101 officers and men. Three-quarters of the crew are there to cater for the passengers

1940
Cunard launches the *Queen Elizabeth*. She makes her maiden voyage in 1940 as a Second World War troopship and her first commercial voyage in 1946

1968
Cunard launches the *Queen Elizabeth II*, known as the *QE2*

1997
P&O launches cruise ship *Grand Princess*

Rank & Style

The types of clothing worn at sea include functional garments, ceremonial uniforms and informal leisure wear, with a longstanding interchange between nautical and civilian design.

Regulation uniform for Royal Navy officers was introduced in 1748, at the request of officers themselves, who wished to be recognized as servants of the Crown. There were two patterns: ceremonial or 'dress' uniform and everyday 'undress' uniform. Gold braid, epaulettes, stars and stripes have all been used since to show differences of rank and status.

Until naval seamen's uniform was introduced in 1857 sailors had to buy their own clothing, often from a 'slop' chest of standard clothes, provided by the ship's purser. Even when regulation clothing came in seamen had to 'make up' their own kit from cloth supplied and it was not until the 1900s that ready-made clothing became standard issue.

The First World War (1914-18) brought new developments in naval uniform. In 1918 the Board of Trade introduced an official Merchant Navy uniform to be worn by all certificated officers. The same year saw regulation uniform introduced in the Women's Royal Naval Service (WRNS), established in 1917.

Naval and nautical style became popular with civilian designers. The well-known 'sailor suit' has been an enduring fashion since the mid-19th century. 'Bell-bottom' trousers have had several phases of popularity. Liner travel and yachting inspired other 'nautical' fashions such as the outfit of blue blazer, white trousers and 'deck' shoes. Fishermen's jerseys and smocks have also been fashion items at various times.

Naval dress has continued to develop to meet new demands. 'Whites' for wear in tropical climates have been joined by Arctic kit, diving suits, and garments designed to protect against explosive 'flash' hazards and nuclear fall-out. 'Survival suits' made from synthetic materials, also protect naval personnel and civilians alike from the hazards of the sea itself.

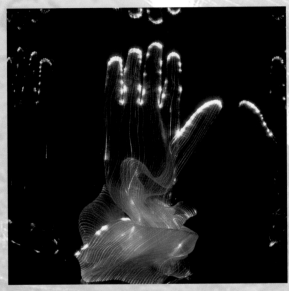

This glove is one of the first articles of clothing to be produced from optical fibre material. This material is being developed for protective military clothing. It has the potential to sense chemical agents and to change colour according to extremes of temperature. [E0186-4]

A model emerging from a hatch aboard HMS *Monmouth*, sporting a nautical-style hat specially designed by the milliner Stephen Jones. [D9295-2/10]

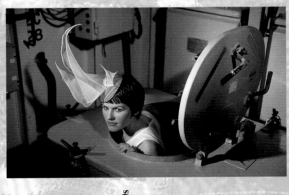

1748

19th century

1830s

1840s

Sailor-suit popularised by ro~

Introduction of regulation uniform for officers in the Royal Navy

Sea bathing and seaside resorts become increasingly popular with upper and middle classes

First purpose-built diving equipment used by the Deane brothers to investigate the wreck of the *Royal George* off Portsmouth

Survival suit worn by yachtsman Tony Bullimore in January 1997 when his yacht capsized in the Southern Ocean. [E0010]

Sealskin suit worn by engineer James Wootton on Captain George Nares's Arctic Expedition, 1875-76. The outfit consisted of a long jacket, trousers, helmet and large hanging mittens. The bristly skin of the Greenland seal was preferred for warmth and durability. [D8414]

FACT FILE

The design of the sailor's blue-jean collar with the flap over the back, was originally to keep the jacket clean when seamen wore longer hair and pigtails.

Admiral of the Fleet's full-dress uniform of King Edward VIII, 1936, afterwards HRH The Duke of Windsor (1894-1972). [D1793]

1857
Introduction of regulation clothing for non-commissioned ranks in the Royal Navy

In Europe and the USA a one-piece 'combination' bathing-suit is designed for men. The design is adapted for young women in the 1900s

Late-19th century

1890s
Tropical kit, or 'whites', introduced for the Navy in Egypt and other countries

1900s
Royal Navy finally adopts practice of issuing ready-made clothing

1918
Regulation uniform for Women's Royal Naval Service. The Board of Trade introduces official Merchant Navy uniform

Late-20th century
Introduction of protective clothing for war at sea

9

Maritime Lor

London has always been at the heart of Britain's economic and social development. Shipping, in all its aspects, has played a significant part in the city's creation and its rise to prominence.

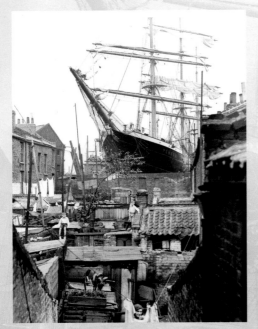

The barque *Penang* in the Britannia Dry Dock, Millwall, 1932. [D39610]

London's early growth, from Roman times in the 1st century AD, was based on the Thames. By the 17th century, the port had captured almost nine-tenths of England's overseas trade.

From the early period there was a growing need to maintain the river and to provide facilities for ships and cargoes, as well as to profit from trade. Much of the history of the port is of the tensions between vested interests – trading companies, dockside labour, transport providers – and the tendency towards centralization of management and maintenance, often backed by government. In the 19th century, when Britain was a major imperial power, Parliamentary legislation ushered in successive waves of building in the port, creating a system of enclosed docks and bonded warehouses handling imports, exports and re-exports. East and south of the river, sprawling and often insanitary housing for those who made their living from the Thames and its industries expanded at an even faster rate.

The financing of maritime trade, the chartering and insurance of ships and cargoes, was initially fairly informal and conducted in the coffee houses of the City. But as business grew, so did the need for more stable trading structures and for new financial methods backed by institutions able to withstand losses

as well as reap profits. The century after 1690 saw the establishment of the Bank of England, Lloyd's of London, the Stock Exchange and numerous other exchanges, trading in specific commodities such as metals.

Although maritime London's share of trade declined in the second half of the 20th century, it has maintained its financial pre-eminence. Lloyd's remains the centre of the marine and other insurance markets. The Baltic Exchange is the world centre for ship charter. The Greenwich Meridian makes London the centre of world time, enabling the City to conduct business with New York and Tokyo in the same day. London is also the headquarters of the International Maritime Organisation, founded in 1948 by the United Nations to establish international standards of safety at sea.

FACT FILE

Roman London grew up around the area now known as Southwark. The Romans built the first London Bridge. The name Thames comes from the Latin *Tamesis*.

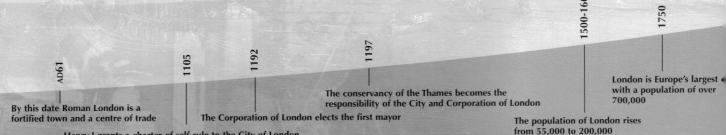

AD61
By this date Roman London is a fortified town and a centre of trade

1105
Henry I grants a charter of self-rule to the City of London

1192
The Corporation of London elects the first mayor

1197
The conservancy of the Thames becomes the responsibility of the City and Corporation of London

1500-1600
The population of London rises from 55,000 to 200,000

1750
London is Europe's largest with a population of over 700,000

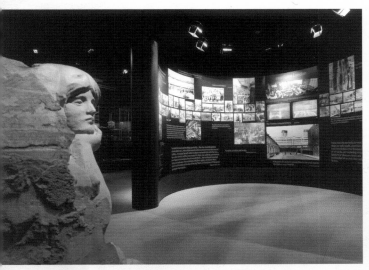

'Maritime London' gallery and a female stone statue carving. [E7341]

Designed by Richard Rogers, this contemporary building in Leadenhall Street, City of London, has been home to Lloyd's since 1984. [D9957]

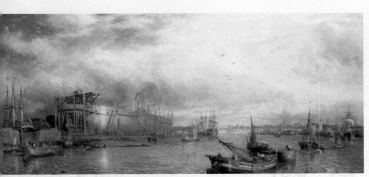

Building the Steamship Great Eastern, by William Parrott. Brunel's huge vessel, the largest afloat, was built at John Scott Russell's Millwall yard and launched in 1858. [BHC3384]

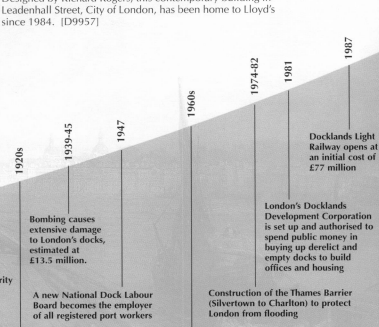

1840s

First railway links to the docks

first phase of dock building, including st India Dock (opened 1802), East India ck (1803), London Docks (1805), Katherine's Dock (1828). These new npanies enjoy monopolies for the first nty-one years of their existence. er, as their monopolies end, several he companies merge

1868-80

Another round of building, including Millwall Docks (1868), Tilbury Docks (1886) and the Royal Albert Dock (1880)

1908

The Port of London Act brings the management of the port under the control of the Port of London Authority (PLA), established in 1909

Introduction of the Dock Labour Registration scheme, and a minimum wage for dockers

1920s

1939-45

Bombing causes extensive damage to London's docks, estimated at £13.5 million.

1947

A new National Dock Labour Board becomes the employer of all registered port workers

1960s

Labour disputes and failure to invest leads to London being bypassed in the first phases of containerisation. In 1960 there are over 23,000 men on the Dock Register. By 1971 only 16,500 registered dockers remain, their numbers cut by a severance scheme

1974-82

Construction of the Thames Barrier (Silvertown to Charlton) to protect London from flooding

1981

London's Docklands Development Corporation is set up and authorised to spend public money in buying up derelict and empty docks to build offices and housing

1987

Docklands Light Railway opens at an initial cost of £77 million

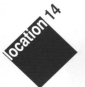

Trade & Empire

'The conquest of the earth ... is not a pretty thing when you look at it too much.'

JOSEPH CONRAD (1857-1924)

Between the 16th and 20th centuries Britain acquired the largest overseas empire the world has ever known. At its peak in 1921 this included almost a quarter of the Earth's land surface and nearly a third of its population.

However, within twenty years of Indian independence in 1947, the Empire was dismantled as Britain recognized it could not be maintained against widespread decolonization movements.

Imperial expansion was rarely the result of any 'grand plan' and took place for many reasons. Maritime trade was at the heart of empire and its profits made Britain one of the wealthiest European nations in the 18th century, leading to her early industrialization. Britain's imperial expansion then started to be driven by the need to find new markets for manufactured goods, which industry produced in quantities far in excess of those needed at home.

The rapid technological advances, shifts in trading patterns, and growing empire brought new notions about imperialism. Empire came to be seen as a 'civilizing mission', with the export of British goods seen as part of a wider export of all that was best in British culture. Britain started to believe that its empire was the result of some innate superiority of natural character, rather than economics and military and naval power.

However, the rise and fall of Britain's empire was also a story of shifting balances of power, exchanges of cultures and mixing of peoples. Its legacies are still with us today.

A view of the European factories at Canton by William Daniell (1769-1837). Canton was the centre of the Chinese tea trade. During the 18th century, tea became a fashionable and more popular drink in Europe. By 1794, Britain was buying over nine million pounds of it annually. [ZBA1291]

Enamelled telescope by Frazer & Son, London, c.1790. This telescope was among the gifts presented to the Chinese Emperor by Lord Macartney during his mission of 1793 to gain greater access to China for British goods. [D9590]

1492
Christopher Columbus, in the service of Spain, lands in San Salvador

1560s
English merchant and adventurer John Hawkins takes first West African slaves to supply Spanish settlements in the Americas

1577-80
Circumnavigation of the world by Francis Drake in the service of Elizabeth I of England

1580s
Schemes to plant English settlers in Virginia, North America

1600
Creation of London-based East India Company

1630-1700
Half a million men and women emigrate to colonies, two-thirds to North America

1641
Beginning of slave trade to Barbados

Figurehead of the first-class paddle sloop HMS *Bulldog* (1845). [E7342]

Bronze figure of a naval brigade seaman in landing rig, *c.*1882. Naval brigades saw action across the Empire, especially during the Indian Mutiny (1857-58), the invasion of Egypt (1882) and the Boer War (1899-1902). [D4309-1]

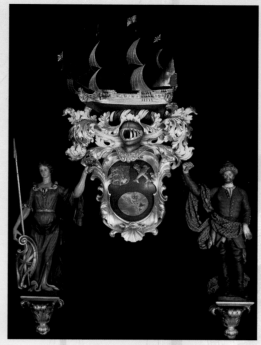

Coat of arms of the South Sea Company, about 1712, which hung at the Company's office at the corner of Bishopsgate and Threadneedle Street in London. [D4847]

Figurehead of HMS *Seringapatam*, about 1809. The figure represents Tipu Sultan, Muslim ruler of Mysore in India, and a strong and dangerous enemy of the British, who finally defeated and killed him at the Battle of Seringapatam in 1799. [D9805]

1711
Formation of the South Sea Company

1757-59
Clive's victory over the French at Plassey (1757) and Wolfe's at Quebec (1759) secure British hold on India and Canada

1775-83
Britain loses sovereignty of its 13 North American colonies in War of American Independence

1787
First convicts sail from England to Botany Bay, Australia

1807
Britain abolishes slave trade

1833
End of East India Company monopoly in China trade

1842
End of the first Anglo-Chinese opium war. Britain acquires Hong Kong

1858
East India Company abolished

1899-1902
Anglo-Boer war in South Africa

1947
Independence for India and Pakistan begins British post-war decolonisation process

1997
Hong Kong returns to China

13

Art & the Sea

The sea has always been a source of artistic inspiration. Its vastness and power have supplied immediately recognizable symbols for moral and religious works of art. It has been the site of the rise and fall of nations, and of sacrifice and heroism. A wide range of the NMM's art collection is displayed in the Queen's House, see page 2

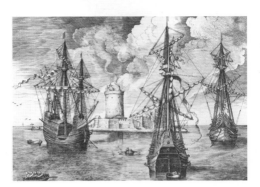

Frans Huys (c.1522-62) after Pieter Bruegel the Elder (c.1525/30-69), *Three Men-of-War before a Castle*, engraving, first state, 1562. [PAF7123]

At the same time its landscape, and those who make their living from the sea, have provided images that embody individual, humanist values, and the quiet dignity of everyday life and labour.

The rise of maritime art was closely linked to that of urban life and national identity, themselves driven by increasing access to open seas and new lands. For example, Renaissance and 17th-century artists celebrated the sea's relationship with trade, the transformation of ports into cities, and the growth of royal or republican navies. Large 'seascapes' including ships suited the tastes of noble families, wealthy corporations and merchants who used them.

From around 1700, maritime art became a vehicle for nationalism. Portraits of naval commanders and their victories epitomized national endeavour; the coast and ships symbolized the defence of the nation. In the 20th century, governments employed artists to record war at sea and the war effort in home ports.

This public art was paralleled by the growth of a more intimate portrayal of daily existence on or by the sea. Coastal and river scenes, for example, formed an important element in landscape painting. Impressionism explored the light on the waves, or figures on the shoreline. Some artists portrayed the mainly middle-class recreations of the 'seaside'. Others sought out the labouring poor in fishing villages, often creating idealized pictures of rural lifestyles that were being swept away by progress and science. Even Modernism found this kind of inspiration from the sea, as the last great wilderness and an imaginative escape from the pressures of urban existence.

These less troubled images have become dominant as the lives of most people have grown increasingly distant from maritime concerns. At times the sea again bursts in on us in all its power, as countries go to war, or as tidal waves destroy lives and property. The progress of such events, however, is now more usually recorded on film than on canvas.

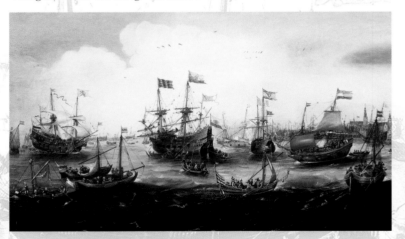

Andries van Eertvelt (c.1590-1652), *The Return of the Dutch East India Fleet, 1 May 1599: the 'Hollandi 'Mauritius', 'Amsterdam' and 'Duyfken' in Harbour*, oil on panel, before 1627. In the 17th century the Dutch government, city authorities and merchant bodies like the Dutch East India Company were all kee patrons of marine artists. [BHC0748]

1360 BC

One of the earliest representations of an Ancient Egyptian vice-regal barge is painted on a wall in a tomb in Thebes

c.1400-1600

Ships and marine landscapes feature in Renaissance altar-pieces, atlases, maps and charts

17th century

The great age of marine painting in the Netherlands. Artists active in this period include Hendrick Vroom (1566-1640), Simon de Vlieger (1600-53), Willem van de Velde the Elder (1611-93) and his son Willem van de Velde the Younger (1633-1707). In 1672 the van de Veldes emigrate to England

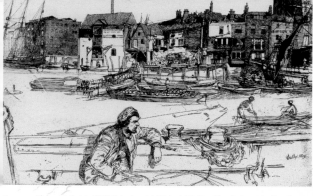

James Abbot McNeill Whistler (1834-1903), *Black Lion Wharf*, etching, third state, 1859; from *A series of sixteen etchings on the Thames*, published in 1871. [PW5495]

Eugène Boudin (1824-98), *Beached Fishing Boats at Trouville*, oil on canvas, 1874. Brought up in rural Normandy, Boudin had to live in Paris, but spent most of his summers painting on the beach of Trouville, a tourist resort. By the 1870s he had begun to turn his back on its social environment, in favour of subjects reflecting nostalgia for Trouville's past as a fishing village. [BHC2378]

Edward Wadsworth (1889-1949), *L'Avant Port, Marseilles* (below), egg tempera on panel, 1924. Wadsworth's early fascination with the machine age died in horrors of the First World War and he returned to a more traditional art.
[BHC4152]

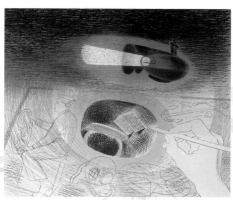

Eric Ravilious (1903-42), *Submarine Dream*, colour lithograph, 1941. In 1939 Ravilious was appointed Official War Artist to the Admiralty. He made studies for these submarine prints while posted to the naval bases at Portsmouth and Gosport.
[PU8080]

Late-17th to mid-18th century

the influence of the Veldes a school of painting emerges and. Their followers Isaac Sailmaker 1721) and Peter y (1681-1749)

Mid- to late-18th century

The rise of the professional marine artist. Those who come to prominence in Britain include Dominic Serres (1719-93) and Nicholas Pocock (1740-1821). Portrait painters such as Sir Joshua Reynolds (1723-92) and George Romney (1734-1802) paint numerous naval officers

Late-18th to mid-19th century

The great age of Romantic painting, with seascapes and battle paintings by Philippe-Jacques de Loutherbourg (1740-1812), J.M.W. Turner (1775-1851) and Théodore Géricault (1791-1824)

1874

Eugène Boudin, influential French marine painter, exhibits for the first time at the Impressionists' exhibition, Paris

Late -19th century

Important marine painters in the USA include Fitz Hugh Lane and Martin Johnson Heade

1914-18

First World War. Canadian and British governments commission artists to paint scenes of war at sea and on land

Early-20th century to 1940s

Emergence of Newlyn (early-20th century) and St Ives (1940s) schools of painting. Ben and Winifred Nicholson in St Ives, whose paintings evoke marine landscapes and forms, also 'discover' local 'primitive' artists such as Alfred Wallis

1939-45

Second World War. War Artists' Advisory Committee established in Britain to record the war; artists engaged include Norman Wilkinson, Eric Ravilious and Richard Eurich

15

South Street

For centuries the designs of ships and buildings have had close associations. The relationship was reinforced by the terms used to describe certain parts of the ship, such as the 'bridge' and the 'forecastle' (foc'sle). As the size of ships grew to carry more guns, bigger cargoes and bigger complements of men, they increasingly resembled floating communities.

In the 19th and early 20th centuries, the demands of transatlantic emigration and tourism, and the expansion of world trade, were increasingly catered for by ships which used the same materials and construction techniques as the colossal railway stations and bridges of the period. In some cases they were designed by the same men. With the introduction of steel-built luxury liners, such ships became modern cities in microcosm, with their apartments, 'streets' and shops providing all the trappings of urban life.

Ships' external decoration and interior design have also drawn elements from civil architecture. Warships went to sea with sterns which resembled 18th-century terraced houses, complete with sash windows. The interiors of liners, often designed by prominent architects, featured decorative schemes based on country houses, Renaissance palaces and even ancient Roman baths. Later, the smoother lines of Art Deco graced the liners, as they did many hotels and apartment blocks.

Up to the early 20th century a good deal of design effort went into disguising the fact that passengers were on a ship in the open sea. More recently we have seen this trend reversed. Ship design has become increasingly innovative, celebrating the nautical experience, while modern architecture has borrowed 'maritime' elements such as external ventilators, port-holes and promenade decks.

FACT FILE

Isambard Kingdom Brunel, who designed and built the steam ships *Great Britain* and *Great Eastern*, was also the architect of Paddington Station, the Tamar railway bridge and other great projects of Britain's first industrial age.

Figurehead from the 74-gun ship *Implacable*, 1800. Originally the French warship *Duguay-Trouin*, *Implacable* fought against Nelson's fleet at the Battle of Trafalgar and was later captured by the Royal Navy. *Implacable's* long and eventful career as a ship of the line, naval training ship, training vessel for Sea Scouts, holiday home for working-class boys and girls, and depot ship ended in 1949 with her being scuttled, but not before the figurehead and stern carvings were salvaged. [D9801-1]

1756
The launch of England's *Royal George*, capable of carrying a full complement of 750 men

19th century
Iron (and later steel) replaces wood, while steam power (later steam turbines) and screw propellers replace sail power

1858
Launch of the *Great Eastern*, designed by I.K. Brunel. The ship, driven by paddle wheel and a screw propeller, is 688 ft long, 82.8 ft broad, with a gross tonnage of 18,915 tons and a top speed of 13 knots

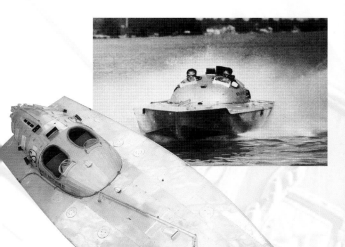

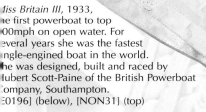

Miss Britain III, 1933,
the first powerboat to top
100 mph on open water. For
several years she was the fastest
single-engined boat in the world.
She was designed, built and raced by
Hubert Scott-Paine of the British Powerboat
Company, Southampton.
[E0196] (below), [NON31] (top)

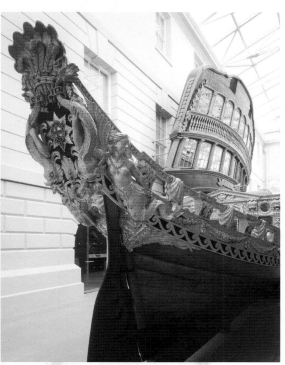

Royal barge designed in 1732 by the architect William
Kent for Frederick, Prince of Wales. It was to be Frederick's
highly visible symbol of political power, dignity, authority
and patronage of the arts. [E0250]

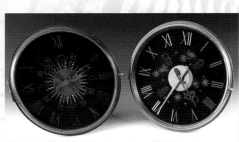

Pair of electric slave clocks designed by
Sir Hugh Casson for the *Canberra*,
1961. *Canberra* was built to serve
P&O's Australia route. Appropriately on
the run to the other side of the world,
the dials of these clocks represent night
and day. [E0008]

1912
Disastrous maiden voyage of
the White Star Line's *Titanic*,
43,500 gross tons

1931
Completion of the BBC's
Broadcasting House
(architects Val Myers and
Watson-Hart), berthed
like a ship in Langham
Place, London

1933
Miss Britain III, a streamlined
power-boat built from the
lightweight material 'Alclad',
becomes the first of its kind
to exceed 100 mph

1936
Launch of Cunard's
Queen Mary

1959-73
Construction of
Sydney Opera
House, Australia,
designed by Jörn
Utzen, its billowing
roof reflecting the
sails of the boats in
the harbour

1961
The design of the P&O passenger liner *Canberra*
'breaks the mould' of modern ship design

1969
Launch of Cunard's liner, *QE2*, then the most
futuristic of modern cruise ships

1998
Launch of P&O cruise
ship *Grand Princess*

Opening of Guggenheim Museum,
Bilbao, its design like a steel wave.
In the same year, the proposed design
for the Scottish Assembly building,
Edinburgh, draws its inspiration from
a boat motif

17

East Street
Making Waves

'Making Waves' explores the workings of the oceans, showing how such phenomena as tides, currents and waves are formed. The display is part of the Museum's wider *Planet Ocean* initiative, promoting awareness the past, present and future of the oceans. As such, it sets the context for displays elsewhere in the Museum

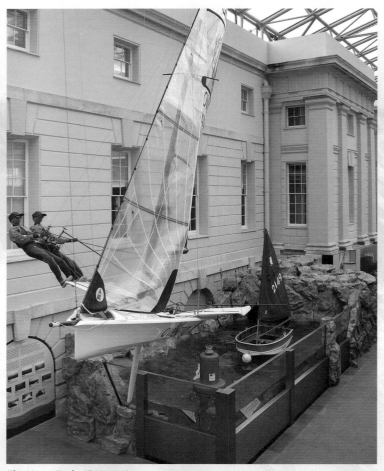

The Wave Tank [F0970-6]

An 11 x 4 m transparent tank and wave-generating machine running the length of East Street, gives a vivid demonstration of how the oceans affect all life on the planet. The tank shows how waves form and finally break on the shore. It can also be used in educational work as a test-tank for children's practical science and technology activities. Accompanying the tank are several interactive devices to help visitors understand the workings of the oceans: a smaller 'do-it-yourself' wave generator and a vortex generating machine.

Close by, a modern, lightweight '49-er' racing dinghy and *Dodo*, an 1890s sailing boat, are displayed (in conjunction with the Royal Yachting Association) to demonstrate how and why boats move through water, and the principles of sailing.

State-of-the-art scientific instruments used to investigate and monitor the complex workings of the oceans are also on show. These include a device for measuring the depth, temperature and salinity of sea water, a high-tech buoy which records information on wave speed and height, and a unique instrument for measuring the speed and direction of ocean currents.

The final section holds a multimedia system called the 'North Sea Experience' for visitors to interact with. This is made up of three sections displayed on plasma screens: 'Weather and Waves', 'Tides and Surges' and 'Latitude and Longitude'. These provide a 'real-time' understanding of what is happening in the North Sea for the day that the visitors are in the Museum.

Once visitors have experienced the physical ocean they are ready to visit the *Planet Ocean* displays – 'Oceans of Discovery' and 'The Future of the Sea'.

The Vortex Machine

location Level 1
East Street
West Street

West Street

Since its foundation in the early 1930s, the National Maritime Museum has acquired a wide range of important objects relating to the sea, ships, time and the stars. A few of these objects are highly unusual, many are functional and some are very large. West Street provides a striking and original architectural setting in which to display some of them.

The centrepiece of West Street is Queen Mary's shallop, a 12.5m (41ft) oak barge displayed aloft with its oars outstretched. It was commissioned in 1689, by King William III, as a coronation gift for his wife and cousin Queen Mary II. At the stern, the gilded decoration of intertwined tulip and oak leaves symbolises the union of the Dutch and English royal families. A prominent royal coat of arms was added during the early Georgian period (1714-1801). When Prince Frederick's barge (displayed in South Street) was taken out of service in 1849, Queen Mary's shallop became the last state barge of the British Crown. Designed for use on the Thames, the shallop was last used by King George V and Queen Mary during the Peace Pageant in 1919 to commemorate the part played by the Royal and Merchant Navies during the First World War.

In stark contrast, is the steam engine of the paddle tug *Reliant,* displayed nearby. Built in 1907 and originally named *Old Trafford*, the 32.3m (106ft) vessel was Britain's last working paddle tug. She worked on the Manchester Ship Canal for 43 years and was then purchased by the Ridley Steam Tug Company, renamed and put to work on the River Tyne. In 1969 the tug was acquired by the Museum where it was the focus of the former Neptune Hall for over 20 years. The engine, which could generate up to 200 horsepower, is a very rare example of a 'grasshopper' engine, so-called because the beam resembles the motion of the insect.

The engine room of the paddle tug *Reliant*. [D4793-1]

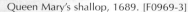

Queen Mary's shallop, 1689. [F0969-3]

Oceans of D

Exploration of the sea began in prehistory, for many reasons and originally in very small craft. Sailors navigated along coastlines by known landmarks and on the open sea by the sun, stars and currents. The knowledge accumulated was passed on in myth and lore.

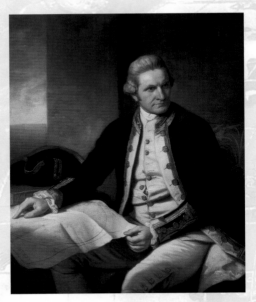

Captain James Cook (1728-79) by Nathaniel Dance (1735-1811). This portrait of the famous explorer and navigator was painted in about 1775. [BHC2628]

From the late 15th century the pace and scope of maritime exploration accelerated as the states of Europe, seeking to expand their empires, sent their ships into the Atlantic, the Indian Ocean, and the Pacific.

Europeans often employed local pilots to guide them. But they developed advantages which enabled them to voyage both further and for longer than other cultures. Their ships were more suitable and their seamen learned new mathematical methods of navigation, based on charts, tables and increasingly sophisticated instruments.

The effects of European exploration were usually beneficial to states which undertook it but could be disastrous for places they 'discovered'. Early patterns of mutually advantageous trade, and of limited settlement, were often replaced by domination based on monopolies, military might and organized religion. The human and ecological costs have been high and influence our attitudes and political relationships today.

Science was always a tool of discovery but 'scientific exploration' began with Captain Cook's Pacific voyages of 1768-80. Darwin's theory of evolution, an outcome of his voyage in HMS *Beagle*, 1831-36, was a successor to the ethnographic and natural observations made under Cook. The *Beagle* voyage itself was also just one in the Royal Navy's vast 19th-century charting of the oceans, a process Cook began, and which from the 1820s saw others continue where he left off, including in the Arctic and the Antarctic. In 1872-76, Captain George Nares's long Atlantic voyage in HMS *Challenger*, was the first concentrating on meteorology and deep-ocean science. By its centenary, in the 1970s, manned submersibles had long reached the deepest ocean floor and satellites for observing the seas from space were developing: in 1993, for example, they discovered the world's densest concentration of active volcanoes in the Pacific. Nevertheless, ninety-five percent of the deep ocean has still to be explored.

'Oceans of Discovery' was generously sponsored by Friends of the National Maritime Museum – see page 31.

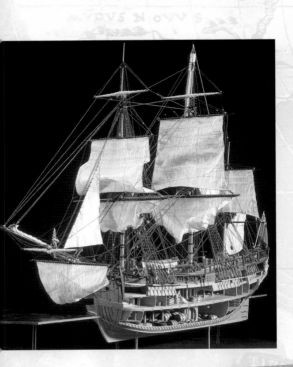

Model of *Endeavour* with the ship's company and stores by Robert A. Lightley, Cape Town, 1975. This 1:48-scale model shows Captain Cook's *Endeavour* before she set sail from Plymouth in August 1768. The length of three London buses, she had to hold just over 100 men with their belongings for three years. [D3358-1]

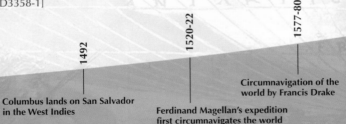

1492
Columbus lands on San Salvador in the West Indies

1520-22
Ferdinand Magellan's expedition first circumnavigates the world

1577-80
Circumnavigation of the world by Francis Drake

covery

This 27-inch terrestrial globe was made by the English globemaker, John Senex. It is one of a pair, the other being a celestial globe. From the beginning of the 17th century, pairs of globes were often included as part of the equipment on board ship. The terrestrial globe contained vital geographical information, though this globe highlights just how much of the world was 'unknown' between 1700 and 1745. Used together with the astronomical data on the celestial globe, the navigator could plot his course through uncertain waters. [D3341-2]

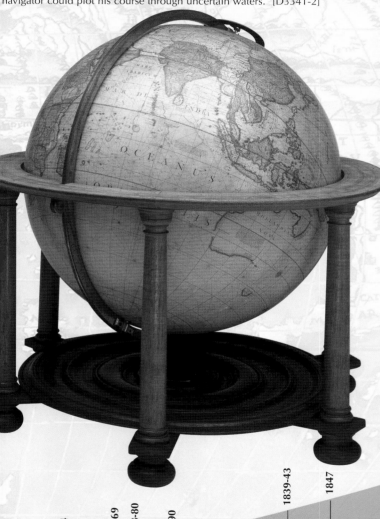

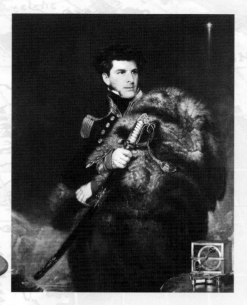

Captain Sir James Clark Ross (1800-62) by John Wildman (active 1823-39). The position of the northern magnetic pole was first found in 1831 by James Clark Ross. The instrument in the lower, right-hand corner of the portrait is a dip-circle, which measures magnetic declination. [BHC2981]

1740-44
Circumnavigation of the world by Commodore George Anson

1766-69
French commander, Louis-Antoine de Bougainville, explores the Pacific

1768-80
Captain James Cook undertakes three voyages into the Pacific and Southern Oceans

1790
Exploration of the north-west coast of America by Captain George Vancouver

1839-43
British exploration of the Antarctic in the ships *Erebus* and *Terror*, commanded by Captain James Clark Ross

1847
Sir John Franklin's expedition disappears in its search for the North-West Passage from the Atlantic to the Pacific

1872-76
Expedition of HMS *Challenger* in the Atlantic for the scientific study of oceanography, meteorology and marine biology

1903-06
Roald Amundsen makes first successful voyage through the North-West Passage from Atlantic to Pacific

1940s
Self-contained underwater breathing apparatus (SCUBA) developed in Occupied France by Jacques-Yves Cousteau and Emile Gagnan

1948
Auguste Piccard constructs 'bathyscaphe' for deep-sea exploration

1960s
USA establishes 'Transit' polar orbiting satellite navigation system

1966-67
Francis Chichester circumnavigates the world single-handed in *Gipsy Moth IV*, taking 226 days, excluding a 48-day stop in Sydney

1968-69
Robin Knox-Johnston wins Golden Globe race, becoming the first man to sail single-handed and non-stop around the world. His voyage, in his boat *Suhaili*, takes eight months

Explorers

'Explorers' gives an overview of exactly what motivated Europeans to explore the vastness of the oceans. These voyages of discovery changed geography and also history, science and our view of the world itself.

The galleries look at early modern European trading and exploration. When Christopher Columbus (c.1445-1506) made landfall on San Salvador in the Caribbean in 1492, he was attempting to find a new trade route by sea to Asia. He died believing he had reached lands that were part of modern-day China.

The Spanish and the Portuguese were dominant in the race to establish trading routes to other parts of the world. Compared to other European seamen, they were accomplished navigators, experimenting with celestial navigation.

After Europeans opened up the Americas, they began to look for shorter sea routes to Eastern markets. The North-East and North-West Passages via the Arctic, were attempted. Many explorers died painful, frozen deaths trying to traverse these icy sea routes.

The British explorer, Sir John Franklin, set off to discover the North-West Passage in 1845. He disappeared and became a legend as some 30 rescue missions were sent to find him. He and all 129 of his men had perished in the bleak conditions. All that was found were poignant reminders, including knives, a boot and tinned food.

Exploration has also taken place under water. The ocean beds are littered with wrecks that reveal a wealth of history – and often a history of wealth. Wrecks are a great source of knowledge about the past.

The *Titanic*, which sank in 1912 on its maiden voyage, is perhaps the most famous modern wreck. It was finally located in 1985 and explored using special manned submersibles and ROVS (Remotely Operated Vehicles).

Hussey's banjo, made in about 1900 by A.O. Windsor. Hussey was a member of Sir Ernest Shackleton's crew on the ill-fated *Endurance*, which was crushed by ice in the Antarctic in 1915. Shackleton led an epic escape, insisting that Hussey save his banjo as 'vital mental medicine' for crew morale. [D9467]

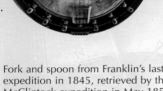

Fork and spoon from Franklin's last expedition in 1845, retrieved by the McClintock expedition in May 1859. [D4483]

Portuguese carracks off a rocky coast, c.1525, by an unidentified Flemish artist. This famous painting shows Portuguese trading carracks, specifically the *Santa Catarina de Monte Sinai*. At the time these ships were the largest in the European world. Able to carry bulk cargoes, they were hugely important in the construction of trading empires. [BHC0705]

Sea boot from Franklin's last expedition in 1845, retrieved in 1879. [D4680]

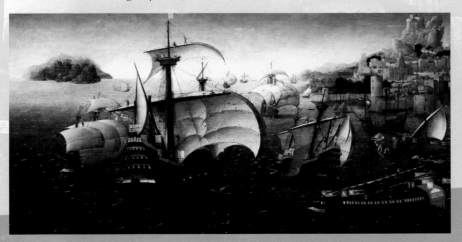

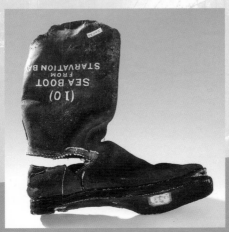

Other Galleries

All Hands

The main children's gallery, 'All Hands' displays sea skills and technology used in the past and the present. The first part of the gallery focuses on people – a Viking, a Tudor explorer, a midshipman, a Victorian shipbuilder and a 20th-century yachtswoman. In addition to a magnificent model of the 74-gun ship *Cornwallis* (built in 1813), it also includes interactive exhibits on diving, propulsion, gunnery, cargo-handling and signalling, with an activity room used for workshops and events.

A view of the 'All Hands' gallery. [D7917-C]

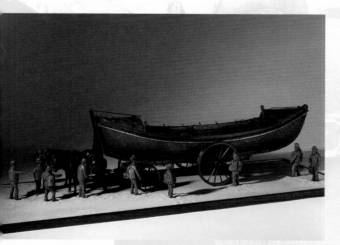

The Bridge

Ships have to operate in all weathers, in calm or in mountainous seas, so danger is never far away. From the first oars and rudders to the development of electronic navigation, travel by sea has always called for ingenious solutions. 'The Bridge', which is currently under development, looks at how sailors have solved these problems over the centuries.

This model represents a lifeboat being prepared for launch in 1877. A team of strong shore helpers was needed to catapult the boat into the foaming sea. [D9971-1]

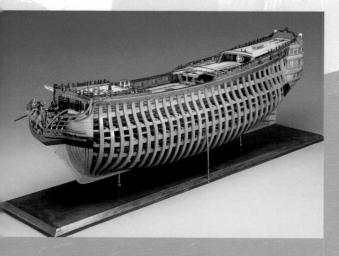

Ship of War

The story of the British sailing warship is told using the Museum's great collection of Navy Board models from the mid-17th century to the age of Nelson. The display also shows the development of types of ship. Famous examples include the *Bellona*, a model used to demonstrate coppering to George III, and the *Royal George*, a flagship sunk at anchor and with great loss of life in 1782.

The *Royal George*, a 100-gun first-rate. Launched in 1756, she suddenly sank with the loss of 900 lives in 1782, while being heeled over for minor repairs off Portsmouth. This is the finest example of 18th-century model making in the collection. [D4082-3]

Other Galleries

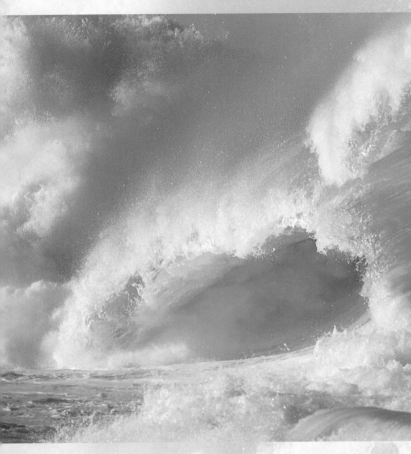

The Future of the Sea

The oceans cover over 70 per cent of the Earth's surface, making up 97 per cent of the planet's living space. Their average depth is two miles (3.3 km). They are the life-support system for our planet, influencing world climate and providing essential resources such as food, energy and minerals.

They also provide opportunities for trade, commerce and recreation, contribute billions of pounds to the global economy and inspire art and culture. Until recently the sea's fertility and its capacity for renewal seemed limitless.

Now it appears that the demands we make on the oceans may be proving too much. Ever-increasing human populations are putting the oceans under great pressure, seriously threatening their health and well-being. Excessive use and exploitation of the oceans is being compounded by other man-made environmental problems.

This gallery, which is in the process of being developed, introduces the many issues and concepts surrounding the importance of the oceans to our lives and, importantly, how we can all make a positive contribution to the future of the planet.

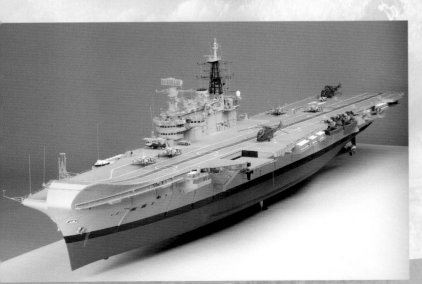

Hidden Treasures

location 13

Scale models of ships have been made in Europe for well over 300 years. The National Maritime Museum holds a collection of over 2500 ship models, generally regarded as being one of the finest in the world. 'Hidden Treasures' displays a range of models that represent ships and submarines of the 20th century. It demonstrates the collection's wide scope and includes models of the first British submarine, Holland No.1, and Hitler's yacht, *Grille*. Models in this collection are displayed in rotation, ensuring access to as much of our collection as possible.

The aircraft carrier, *Hermes*. Launched in 1953, this model shows her as she was fitted during the Falklands War of 1982. In 1986, she was sold to the Indian Navy and renamed INS *Viraat*. This model was commissioned by the Friends of the National Maritime Museum in 1991 from a specialist model maker. [D6574]

Art in the Queen's House

The size and importance of the Museum's art holdings often surprise visitors. As well as 70,000 prints and drawings it has over 4000 oil paintings from the 16th century on. These include the largest collection of British portraits outside the National Portrait Gallery, with works by Lely, Hogarth, Reynolds and Gainsborough, among others. The collection of Dutch 17th-century marine art, and of works by British painters of the sea up to the 20th century, is also the finest in the world. The House generally shows a themed selection, with other rooms devoted to the Tudors and Stuarts and early paintings of Greenwich, or to other special topics or exhibitions.

As part of the centenary celebrations of the National Art Collections fund, in 2003, there is a display of works which the Museum has acquired with the Fund's help. In 2004 the first specialist exhibition on William Hodges (1744-97), the artist who accompanied Captain Cook's second Pacific voyage and later worked in India, will occupy half of the fine rooms on the upper floor. The House is also a focus for art-based education projects and holds regular winter shows by the Canvas Club, the art group of the Friends of the Museum.

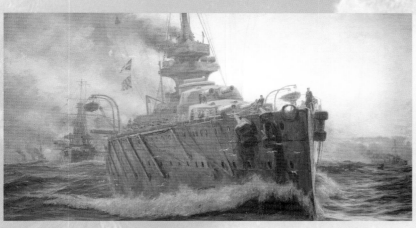

Masters of the Sea: the First Battle Cruiser Squadron, by William Lionel Wyllie, 1915. [BHC4167]

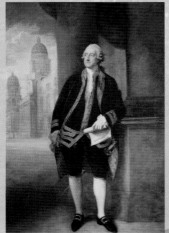

John Montagu, Fourth Earl of Sandwich, 1718-92, First Lord of Admiralty by Thomas Gainsborough, 1783. [BHC3009]

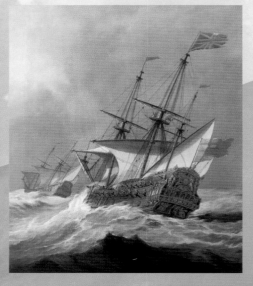

'Resolution' in a Gale by Willem van de Velde, the Younger, c.1678. [BHC3582]

Please note that, since displays change, the pictures illustrated may not be in the House at the time of your visit.

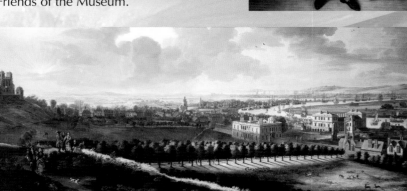

Greenwich and London from One Tree Hill by Johannes Vosterman, c.1680. [BHC1808]

The Queen's H

When moves to form the National Maritime Museum began, in the 1920s, it was originally going to occupy just Queen's House – the 17th-century royal villa at the heart of the modern Museum and of the Maritime Greenwich World Heritage Site. At that time the House and its flanking wings were still the Royal Hospital School.

It was in 1934, after the School moved to Suffolk, that the Museum was founded and took over all its buildings. The additions were because the House was both too small but also architecturally too significant for many museum uses.

The Queen's House is the last surviving building of the Tudor Palace of Greenwich, which stood where the Old Royal Naval College does now. The Palace was redeveloped by King Henry VII from the 1490s on, replacing earlier buildings, with gardens stretching back to the walled Greenwich to Woolwich road, where the Museum colonnades now stand. It was here, and partly as a private bridge over the road between the Palace and Royal Park, that the Queen's House was begun in 1616. The builder was Inigo Jones, the first great British architect, working

originally for Anne of Denmark, the queen to James I. However she died in 1619. For a period, work on the House stopped and Jones only completed it about 1638 for Henrietta Maria, wife of Anne's son Charles I. It is the first truly Classical building in England, based on Renaissance villas which Jones had studied in Italy. In its brief royal use, before the Civil War broke out in 1642 and destroyed the Stuart court for which it was created, it was a richly furnished and private 'house of delight' for the Queen. While the old Palace fell into decay in the Civil War, and was later pulled down, the House survived in official use. Charles II made some changes to it in 1662 and in the 1670s gave studio space in it to the Willem van de Veldes, father and son, who brought the Dutch art of marine painting to England under his patronage. It was later a royal 'grace

and favour' residence until, in 1806, it became the new home of the Royal Naval Asylum – a large orphanage school – for which the colonnades and flanking wings were built. This developed until renamed the Royal Hospital School in 1892.

The House was restored for the Museum before it opened in 1937, with further major work in the 1980s and 1990s. It is now used to tell its own story, to display aspects of the Museum's superb art collections, and for contemporary art projects and educational work. It is also an elegant venue for appropriate events and hospitality, distantly echoing its original uses.

Interior view of the Great Hall with its original painted woodwork and the 1630s floor of Italian and black Belgian marble. [E5410_1]

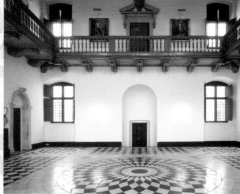

The Tulip Staircase, completed in about 1635 at the height of the European 'tulip craze', derives its name from the beautiful pattern of the wrought-iron balustrade. [E5411]

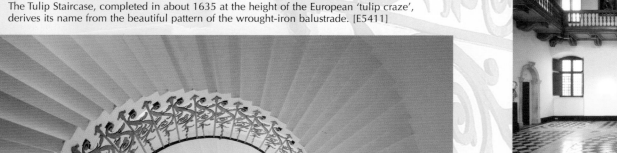

1616-17

Inigo Jones designs and begins Queen's House for Anne of Denmark, wife of James I

1619

Work on the Ho
on the death of

26

s e

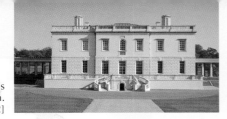

Built by Inigo Jones, the Queen's House is the first truly Classical building in Britain.
[D5021_2]

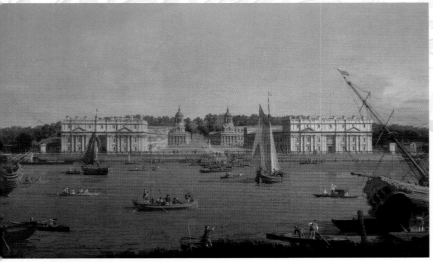

Greenwich Hospital and the Queen's House from the north bank of the Thames, by Canaletto, c.1752. [BHC1827]

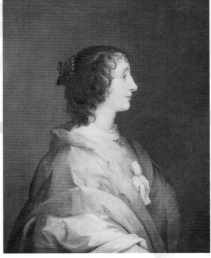

Queen Henrietta Maria, 1609-69.
Studio of Anthony van Dyck, c.1638
[BHC2761]

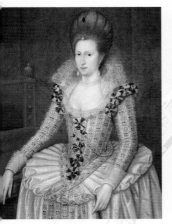

Anne of Denmark, by John De Critz c.1605. [BHC4251]

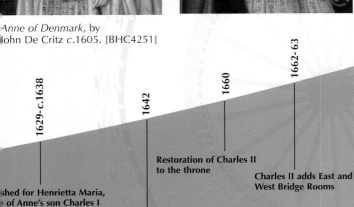

James I, 1566-1625, by John De Critz, c.1610.
[BHC2796]

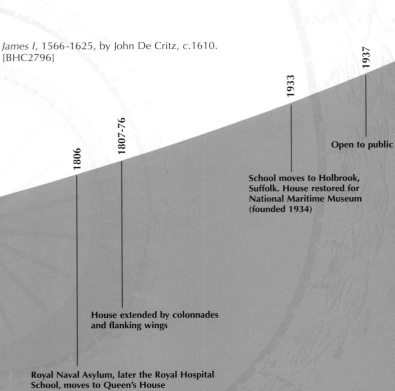

1629-c.1638
shed for Henrietta Maria, e of Anne's son Charles I

1642
Outbreak of English Civil War. Contents of House dispersed and it becomes an official Parliamentary residence

1660
Restoration of Charles II to the throne

1662-63
Charles II adds East and West Bridge Rooms

1806
Royal Naval Asylum, later the Royal Hospital School, moves to Queen's House

1807-76
House extended by colonnades and flanking wings

1933
School moves to Holbrook, Suffolk. House restored for National Maritime Museum (founded 1934)

1937
Open to public

27

Royal Observatory

The Royal Observatory was founded in 1675 by Charles II to find out the 'so-much desired longitude of places for perfecting the art of navigation'. It was designed by Sir Christopher Wren, also the main architect of the Old Royal Naval College at Greenwich and himself an astronomer.

The Observatory was built on the foundations of Greenwich castle, a hunting lodge and tower previously on the site. In July 1676 the first Astronomer Royal, John Flamsteed, moved into the new building, which has been called Flamsteed House ever since.

By the 1930s the smoke and street lights of London made observing at Greenwich difficult. After 1945 the astronomers began moving to a new 'Royal Greenwich Observatory' (RGO) at Herstmonceux Castle, Sussex, and the 'Old Royal Observatory' at Greenwich was gradually transferred to the National Maritime Museum in the 1950s. Flamsteed House was opened to the public in 1960 and the other buildings were open by 1967, although most have had later restoration. The collection of scientific, navigational and astronomical instruments displayed at the Observatory has continued to grow since that time. The RGO moved from Herstmonceux to Cambridge in 1990 but closed in October 1998. The name 'Royal Observatory, Greenwich' was then reclaimed for the original site, where the Museum today also continues some of the educational work of the RGO.

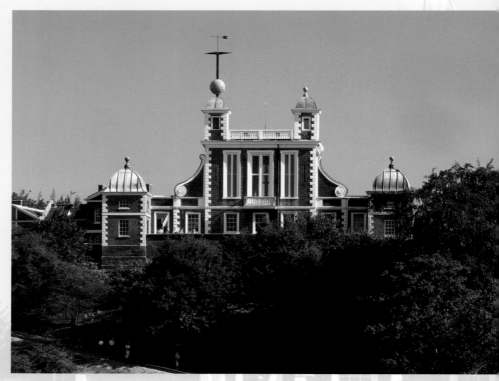

The distinctive façade of Flamsteed House, built by Sir Christopher Wren in 1675-76. [D5611]

THE PRIME MERIDIAN

The Observatory is the source of the Prime Meridian of the World, Longitude 0° 0' 0". Until the 19th century, each country tended to have its own zero meridian. Longitude 0° at Greenwich was adopted as the Universal Prime Meridian in 1884 at the International Meridian Conference in Washington DC, by a majority vote of the 25 countries which attended. Although world time is no longer set at Greenwich but on an international basis co-ordinated in Paris, the Greenwich Meridian is still the baseline of the International Time Zone system and the place 'where East meets West'.

1675

Charles II appoints 1st Astronomer Royal, John Flamsteed, and founds Observatory

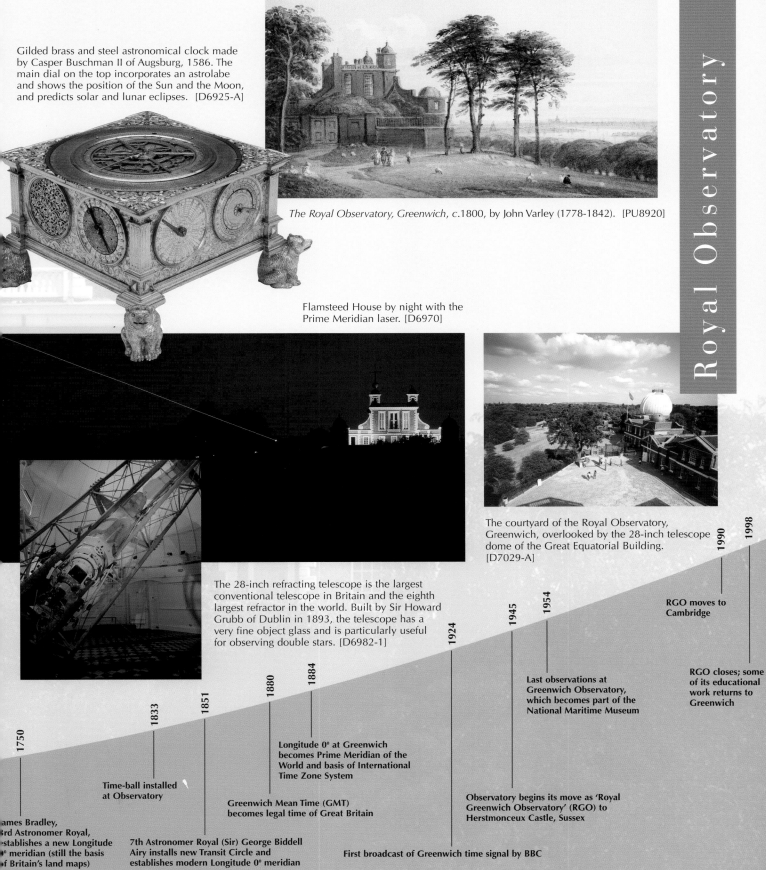

Gilded brass and steel astronomical clock made by Casper Buschman II of Augsburg, 1586. The main dial on the top incorporates an astrolabe and shows the position of the Sun and the Moon, and predicts solar and lunar eclipses. [D6925-A]

The Royal Observatory, Greenwich, c.1800, by John Varley (1778-1842). [PU8920]

Flamsteed House by night with the Prime Meridian laser. [D6970]

The courtyard of the Royal Observatory, Greenwich, overlooked by the 28-inch telescope dome of the Great Equatorial Building. [D7029-A]

The 28-inch refracting telescope is the largest conventional telescope in Britain and the eighth largest refractor in the world. Built by Sir Howard Grubb of Dublin in 1893, the telescope has a very fine object glass and is particularly useful for observing double stars. [D6982-1]

1750

ames Bradley, rd Astronomer Royal, stablishes a new Longitude ° meridian (still the basis f Britain's land maps)

1833

Time-ball installed at Observatory

1851

7th Astronomer Royal (Sir) George Biddell Airy installs new Transit Circle and establishes modern Longitude 0° meridian

Greenwich Mean Time (GMT) becomes legal time of Great Britain

1880

1884

Longitude 0° at Greenwich becomes Prime Meridian of the World and basis of International Time Zone System

1924

First broadcast of Greenwich time signal by BBC

1945

Observatory begins its move as 'Royal Greenwich Observatory' (RGO) to Herstmonceux Castle, Sussex

1954

Last observations at Greenwich Observatory, which becomes part of the National Maritime Museum

1990

RGO moves to Cambridge

1998

RGO closes; some of its educational work returns to Greenwich

29

The Wider Work o...

Research

The Museum has an active research programme, which increases understanding of its collections, sustains high standards of exhibitions, galleries and publications (both traditional and electronic), and supports the development of maritime research in Britain and abroad.

The public face of the Museum's research is the annual seminar and conference programme, which attracts speakers and delegates from all over the world. The conferences are often jointly organized with universities and other institutions. The Museum also runs the annual series of British Maritime History Seminars at the Institute of Historical Research, Senate House, University of London.

The Caird Library

The Caird Library is the most significant reference library of its kind in the world. Collections include rare books, charts and manuscripts dating from the 15th century. The E-Library at the entrance provides a welcoming space, open to all, where you can access the Museum's on-line resources and relax with a magazine or book.

The reading room is open Monday - Friday, 10.00 - 16.45; Saturday by appointment only. (Closed: bank holidays and the third week of February). As a research library we require formal identification when applying for a reader's ticket. The E-Library is open during Museum open hours.

Library and manuscripts catalogue: www.nmm.ac.uk/librarycatalogue

At the entrance to the 1930s reading room is the Caird Rotunda, designed by Sir Edwin Lutyens, with Sir James Caird's bust by Sir William Reid Dick. [F0940_2]

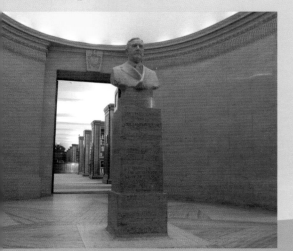

The Virtual Museum
www.nmm.ac.uk

Don't forget, you can continue to explore the Museum, its work and collections long after your visit. Whatever your interest you' find something for you on this award-winning website; from on-line learning resources and illustrated catalogues to astronomy fact-files and an on-line shop.

Education and Interpretation

The Education and Interpretation Department provides programmes and resources to increase access to the Museum collections for all audiences. It aims to inspire, motivate and engage visitors of all ages with the Museum's subject areas – the sea, ships, time and the stars.

School programmes are free of charge. They include actor-led programmes and curriculum-focused direct teaching sessions for subjects including history, art, geography, astronomy and science. Specialist programmes for A-levels, GNVQs and vocational education are also available.

A wide variety of events related to the temporary exhibitions programme and the main galleries encourages adults and families to explore the Museum. Programming for adults includes drop-in events, talks and tours, practical workshops and courses. Family provision includes drop-in craft workshops, trails, activity backpacks and family activity days on a range of themes, from art to astronomy.

For information on our services for schools, bookings and general enquiries contact us on 020 8312 6608, e-mail: bookings@nmm.ac.uk or visit www.nmm.ac.uk/learning

The Open Museum

The Open Museum has been running since 1992 and offers a stimulating programme of lectures and talks that explore diverse topics – from aspects of the sea and shipping to time, astronomy and navigation, local history and the arts. It offers something for people of all ages, giving them the opportunity to learn for pleasure or as a step forward to academic study. Further details of the programme, which is published each summer, can be obtained from the Open Museum Administrator on 020 8312 6747, e-mail: openmuseum@nmm.ac.uk or visit www.nmm.ac.uk/openmuseum

Journal for Maritime Research

Launched in 2000, this was the first fully refereed electronic journal in the field of maritime research. Its aim is to publish high-quality, multi-disciplinary articles and reviews reflecting the diversity of the subject. The *JMR*'s website address is www.jmr.nmm.ac.uk

Visitors navigate the website and on-line learning programmes in the E-Library.

Maritime Heritage at the National Maritime Museum

Through the United Kingdom Maritime Collections Strategy the National Maritime Museum works with partner museums across the UK to promote greater public awareness of and access to the nation's rich maritime heritage. The recently opened National Maritime Museum Cornwall, in Falmouth, now displays the national small boat collection (previously in store) in its new, award-winning, water-side location. NMM also takes an active role in the preservation of the UK's fleet of historic ships through its support of the National Historic Ships Committee – a group dedicated to safeguarding the future of the UK's most important historic vessels in both public and private ownership.

Research Fellowships

The Museum offers a number of research fellowships each year. The Caird Fellowships range from short-term awards of two to three months to one-year post-doctoral fellowships, and are designed to support advanced academic work on the Museum's collections or in its subject areas. The two-year Sackler Fellowship is offered for work on the history of navigation or astronomy.

For further information on the conference and seminar programme, and on fellowships, please contact the Research Administrator on 020 8312 6716 or e-mail: research@nmm.ac.uk

Friends of the National Maritime Museum

The Friends, founded in 1987, raise funds for and awareness of the Museum. Then, as now, members enjoyed privileged access to galleries, exhibitions, curators and the reserve collections, as well as a programme of special Friends' events encompassing lectures, galas, visits, sailing trips and holidays at home and overseas.

The Friends have so far given over £1million to the Museum to acquire items as different as a massive Type-23 frigate propeller and a model of the Eddystone Lighthouse. They sponsored the 'Oceans of Discovery' gallery, encourage members to 'Adopt an Item' by donating money for specific conservation needs, and provide a volunteer resource.

For more information and to join, contact the Friends' Office on 020 8312 6678, e-mail: friends@nmm.ac.uk or visit www.nmm.ac.uk/friends

This propeller (located in West Street) was made by Stone Vickers of Erith, Kent, for a Type-23 frigate, the latest class in the Royal Navy. (Acquired and installed with the support of the Friends of the National Maritime Museum) [E0045]

Information

The National Maritime Museum is the largest maritime museum in the world. Its collections include manuscripts and rare books, 2,500 ship models, 4,000 paintings, 50,000 charts and 750,000 ship plans with hundreds of scientific and navigational instruments, chronometers, globes and large holdings of decorative and applied art.

The Museum also includes the Queen's House and the Royal Observatory, Greenwich. The Observatory is a short walk from the Museum through Greenwich Park.

Opening Times: 10.00-17.00 hours daily, last admission 16.30 hours. (Please enquire for dates of summer opening.) Closed 24-26 December inclusive. CCTV is in operation in all galleries. Please do not touch the exhibits. No dogs (except assistance dogs). Smoking, eating and drinking are not allowed in the galleries. Photography is not permitted inside the buildings or on the site. Please check in advance for changes to opening dates and times by calling the NMM bookings unit on 020 8312 6608 or e-mail: bookings@nmm.ac.uk

Items on display may change. Please contact the Museum in advance if you wish to view a particular item.

For general enquiries please contact:
NATIONAL MARITIME MUSEUM
Greenwich
London
SE10 9NF

Tel: 020 8858 4422
Fax: 020 8312 6632
or visit the National Maritime Museum website:

www.nmm.ac.uk

For information on our services please contact the following departments:

CONFERENCES AND SEMINARS
For programme information please call
020 8312 6747 or e-mail: research@nmm.ac.uk

FILM ARCHIVE
The Museum's film archive houses more than 1500 films dating back to 1910.
For more information please call
020 8312 8522/6727 or fax 020 8312 6533 or e-mail: film&filming@nmm.ac.uk

FILM LOCATION SERVICES
The combined sites of the National Maritime Museum, the Queen's House and the Royal Observatory, Greenwich, provide unique, elegant and historic locations for filming.
For more information please call
020 8312 8522/6727 or fax 020 8312 6533 or e-mail: film&filming@nmm.ac.uk

HISTORIC PHOTOGRAPHS
The Museum's historic photographs collection contains the country's finest maritime photographs.
For more information or to place an order please call 020 8855 1647 or fax 020 8312 0263 or e-mail: plansandphotos@nmm.co.uk

MAPS AND CHARTS
The hydrography and cartography collections contain a large number of printed charts, atlases and sailing directions.
A reproduction service is available.
For more information please call 020 8312 6757 or e-mail: picturelibrary@nmm.ac.uk

PICTURE LIBRARY
There are more than 400,000 images including more than 4000 oil paintings from the 17th to 20th centuries, 50,000 prints and drawings and over 40,000 other images from the Museum's collections.
For more information or to place an order please call 020 8312 6645 or e-mail: picturelibrary@nmm.ac.uk

PORT
'Port' is the Museum's subject-based information gateway on the Internet, dedicated to maritime studies.
Access 'Port' at www.port.nmm.ac.uk

RESEARCH ENQUIRY SERVICE
A fee-paid research service is available to anyone who is unable to visit the Museum.
At the Royal Observatory subject specialists offer expertise in the fields of astronomy and navigation, hydrography, horology and scientific instruments.
For more information please call
020 8312 6712 or e-mail: lxveri@nmm.ac.uk

RESEARCH FELLOWSHIPS
For information please call 020 8312 6716 or e-mail: research@nmm.ac.uk

PUBLISHING
The Museum has a flourishing publishing programme covering its collections, maritime history, research, children's and educational books.
To request a catalogue call 020 8312 6671 or email: publishing@nmm.ac.uk
Mail order available.

EVENTS
The National Maritime Museum offers a wealth of corporate and private hospitality and entertainment opportunities in the heart of Greenwich.
For more information on entertaining at the National Maritime Museum, Royal Observatory and the Queen's House please call the Events Department on 020 8312 6693 or e-mail: events@nmm.ac.uk

REGATTA CAFÉ AND UPPER DECK COFFEE BAR
The Café and Coffee Shop are open during normal opening hours. The Coffee Shop provides a quick and convenient quality snack and beverage service for visitors. The Café offers a more comprehensive morning, lunchtime and afternoon menu.

SHOPPING
The shops at the National Maritime Museum and Royal Observatory offer a wide selection of gifts, books, postcards and souvenirs reflecting the Museum's remarkable collections and special exhibitions. Our aim is to offer high-quality items that are decorative, inspiring and informative to our visitors.

Over 1000 of the items from our site shops are now available on-line through a secure credit card payment system at www.nmm.ac.uk/shop
Do not worry if you have no access to the internet as many items are also available by mail order.
Please call 020 8312 6700 or e-mail: shopweb@nmm.ac.uk

SPONSORSHIP
For information on how to become involved in the development programme please contact the Head of Corporate Development, National Maritime Museum, on 020 8312 6674 or e-mail: ilee@nmm.ac.uk

VISITORS WITH DISABILITIES
The Museum is committed to the development of facilities for disabled visitors. Flat access is via the North Entrance. There are specialist programmes, large print guides, touch packs and audio guides available from the Information Desk.
Please call 020 8312 6608 or e-mail: bookings@nmm.ac.uk